IMAGES OF ENGLA

Saffron Walden

IMAGES OF ENGLAND

Saffron Walden

Jean Gumbrell

NONSUCH

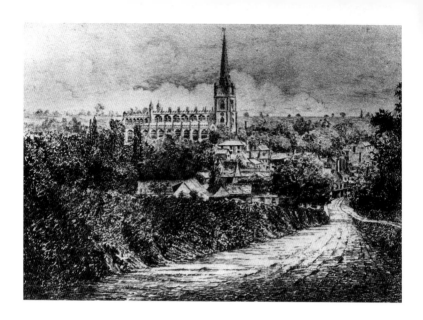

First published 1995
This new pocket edition 2005
Images unchanged from first edition

Nonsuch Publishing Limited
The Mill, Brimscombe Port,
Stroud, Gloucestershire, GL5 2QG
www.nonsuch-publishing.com

British Library Cataloguing in Publication Data.
A catalogue record for this book is available from the British Library.

ISBN 1-84588-121-4

Typesetting and origination by Nonsuch Publishing Limited
Printed in Great Britain by Oaklands Book Services Limited

Contents

Acknowledgements

Jean Gumbrell wishes to thank The Saffron Walden Weekly News, David Campbell and Gray Palmer Ltd, for the loan of the photographs reproduced in this book.

Introduction

Despite the impact of the motor car and its attendant problems, Saffron Walden remains a unique medieval gem in a changing world. Yet the history of this delightful little market town stretches as far back as the neolithic age. Tools and debris from worked flints found in the areas of Abbey Lane and Elm Grove have provided evidence sufficient to support this theory.

Later, Iron Age men formed an agricultural community and worked the land on the site of Elm Grove. Then came the Saxons who created their village of Waledana in the area of Abbey Lane. There seems to be some dispute as to whether the Saxons built a church and some form of castle on what we now know as Bury Hill. But certainly the ruins of the present castle belong to the castle built by the de Mandevilles whose early forbears took up residence in the Abbey Lane settlement after the Norman Conquest. Ansgar the Staller, the last Saxon lord of Walden had been forced to surrender his lands to Geoffrey de Mandeville "a companion of the Conqueror". The castle is assumed to have been built at sometime between 1125 and 1141 and is referred to in a charter of 1141 granting the second Geoffrey de Mandeville (grandson of the first) permission to move the market at Newport to "his castle at Walden". Thus it was that Walden became Chepyng Walden (Chepyng, later Chipping, meaning "market" in old English).

By the Middle Ages, Chipping Walden was a flourishing centre for the wool and weaving industry. This in turn led to the cultivation of saffron in and around the town in the late 14th century. The demand for the yellow dye obtained from the stamens of the saffron crocus and the suitability of the local soil for growing the bulb, made a prosperous industry and ultimately Chepyng Walden became Saffron

Walden. In 1549, Edward VI granted the town a new charter. A seal with "walls with four towers, gateway and portcullis enclosing three saffron flowers" was struck which eventually became the Borough Arms. However, towards the latter part of the 16th century the demand for local grown saffron began to dwindle owing to cheaper foreign imports, and had entirely ceased a century later. It was to be superseded by another crop which was also to play an important role in the life of the town, and this was barley.

The barley grown in the Walden area was particularly suitable for the malting industry, and by the 1830s there were 33 maltings in the town. Inevitably, the prosperity of the town was reflected in the growth of the retail trade. As the 19th century progressed family businesses, which were to continue for generations, were founded. Gradually the weaving and malting industries declined and by the turn of the century only 10 maltings were working. In the 1940s, the last one closed down.

Since the middle of the 17th century there has always been a strong Quaker influence in Walden, but one Quaker family in particular left a lasting impression, the Gibsons.

George Gibson, wealthy draper of Malden, opened his miller's shop in the Market Place in 1763. Twenty six years later his son, Atkinson, married a local brewer's daughter, Elizabeth Wyatt, and founded a dynasty of wealth and influence which lasted until the early decades of the 20th century. It has been said of the Gibsons that "business instincts impelled them to make money; their faith compelled them to give it away." Their charity included schools, the Town Hall, Swimming Baths, provision of allotments and land for the building of a hospital. Strangely, reminders of the Gibson family are to be found all over the town, yet none of their descendants live in Walden now.

Two World Wars widened the horizons of what had been a somewhat insular, mainly agricultural, community. The town lost its cattle market in 1981 but still has two market days a week, Tuesdays and Saturdays. Sadly many of the old family businesses have closed down due to a change in shopping habits. Again sadly, many of the old familiar and much loved landmarks have disappeared. Small cottages which, with imagination could have taken their place in modern Walden, have been demolished, and larger buildings so transformed they are now a parody of their former identity. The pictures in this book cover a hundred years of fast moving change in Saffron Walden. Hopefully the changes in the town will not be quite so fast moving during the next hundred years.

One

The Changing Face of Saffron Walden

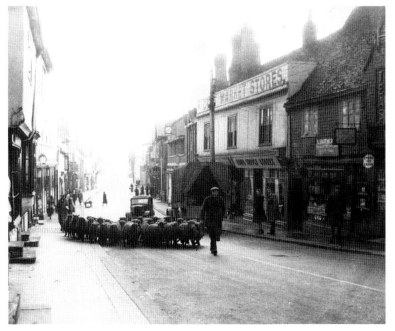

Sheep being driven up Saffron Walden High Street, c. 1940.

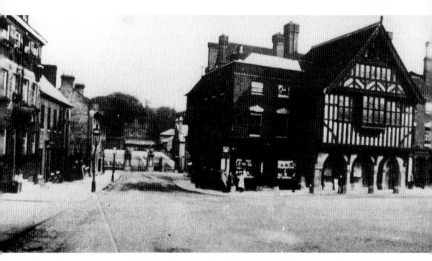

Market Place, c. 1880. On the left can be seen the shell canopy of the seventeenth-century Rose and Crown inn which was burned down early Boxing Day morning 1969. Boots, the chemists, now stands on this site. In the far distance, centre left, is the Borough Market, later known as the Pig Market. The Market, which was built in 1831, was demolished in 1984 to make way for Waitrose (see page 38). On the far right is No. 3 Market Place, once the London and County Bank and now the National Westminster Bank.

Opposite above: This nineteenth-century drawing of the Market Place shows the Rose and Crown, centre, with the Saffron Walden and North Essex Bank on the left. The Bank was designed by the architect, W. Eden Nesfield, for the Gibson family, prominent Saffron Walden Quakers. They amalgamated their Bank with Barclays in 1896.

Opposite below: Market Place, c. 1970, with the Corn Exchange top centre, and Pennings grocers' shop to the right, (see page 77). On the extreme right can be seen part of Rumseys furnishing store, which closed in 1985 and is now Eaden Lilleys.

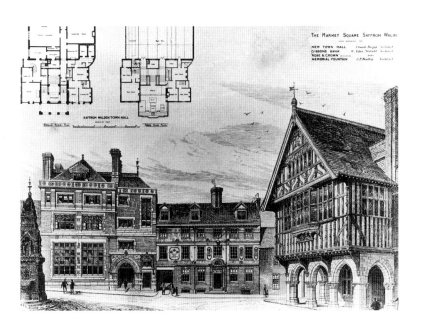

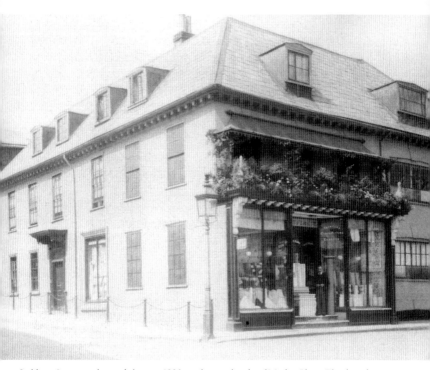

Stebbing Leveretts drapers' shop, *c.* 1890 on the north side of Market Place. This later became Emson Tanners, wholesale gocers, then Rumseys and now Eaden Lilleys. (See page 11.)

Opposite above: Office girls at Emson Tanners, *c.* 1940. Left to right: Mary Harding, Hazel Shelley, Valerie Jacobs (nee Braybrooks), Audrey Brooks.

Opposite below: Rumsey's furnishing store, 1981.

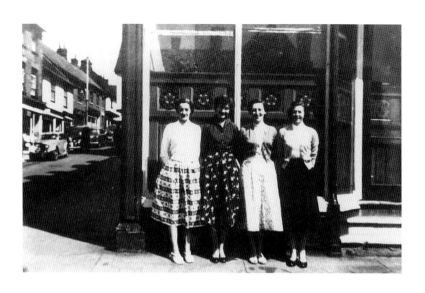

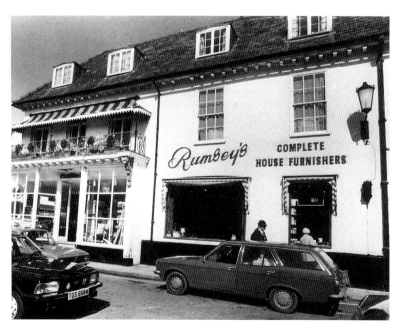

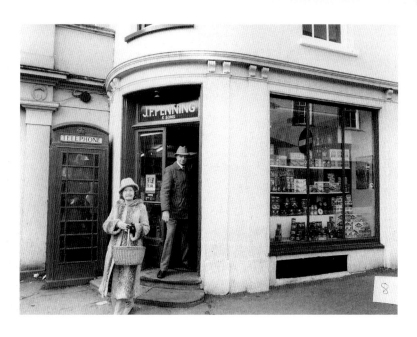

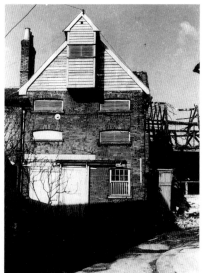

Above: Penning's grocers shop, 1981. Shopping at Pennings was an experience to be savoured. It was like stepping back into the calm unhurried atmosphere of yesterday, when cheese was cut from the round, and ham came off the bone, and the customer was always right (See page 77).

Left: The old town maltings behind Emson Tanners (Eaden Lilleys) which was demolished to make way for the parade of shops known as Emson Close ,1c. 1950.

Opposite above: Demolishing the old town maltings, c. 1950.

Opposite below: Stebbing Leveretts drapers' shop, No1 Market Hill, next door to Penning's, c. 1930

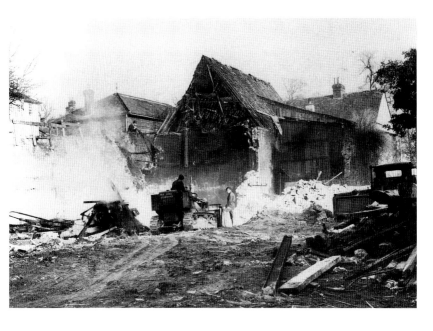

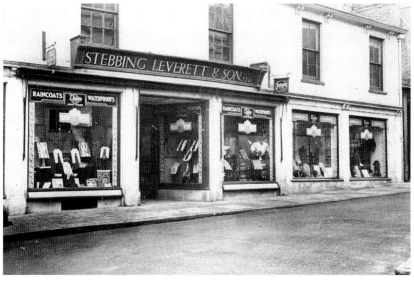

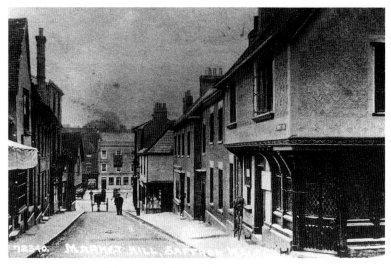

Looking down Market Hill into Market Place, c. 1899. The Old Sun Inn is on the extreme right, and the sign of the Green Dragon public house can be seen centre left. The Green Dragon was closed in the 1930s and is now the Trustee Savings Bank.

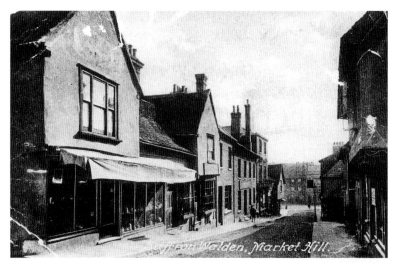

This is the same view of Market Hill taken from a different angle with the Kings Arms on the left. The shop to the left of the Kings Arms was Mr. Bird's antique shop.

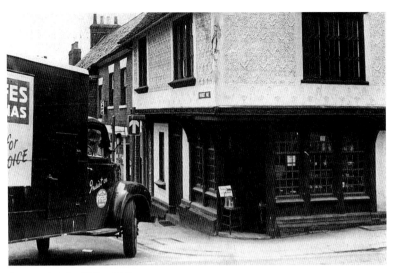

Corner of Market Hill, *c.* 1960.

Old Sun Inn in Church Street before the timbers were limewashed, *c.* 1910. Described as "old houses" here, the inn was built in the 14th century and the pargetting added in 1767. Cromwell is supposed to have stayed at the inn when Fairfax and his officers were stationed in the town.

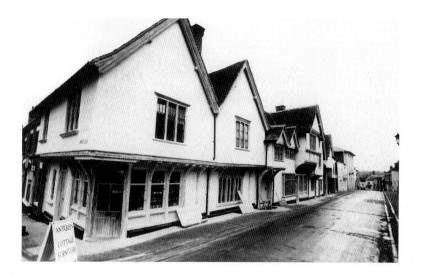

Right: The rear of No.33 (The Grange) Church Street, *c.* 1888. The people in the group are probably Dr Harley, a local general practitioner, and his family. From 1934 until his death in 1967 it was the home of local general practioner. Dr Kenneth Lumsden (See page 118).

Below: An artist's impression of Johnson's Yard in Church Street, *c.* 1890.

Opposite above: The Old Sun Inn up for sale, *c.* 1960.

Opposite below: Now the timbers have been limewashed and the Old Sun is the property of the National Trust, leased for 300 years to Lankester Antiques, *c.* 1960.

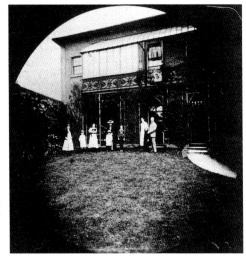

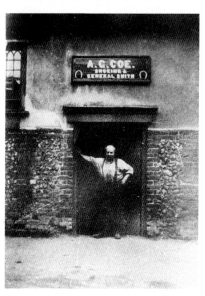

Left: Mr. Coe the blacksmith outside his forge in Church Street in late 1890s. Aimprint now stands on this site.

Below: The Citizens Advice Bureau before it found a permanent home in Church Street, late 1940s.

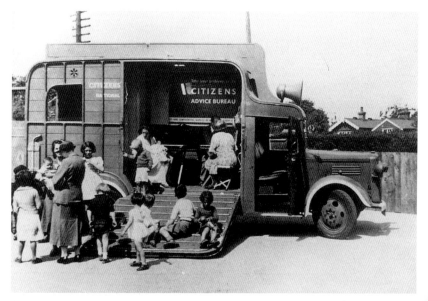

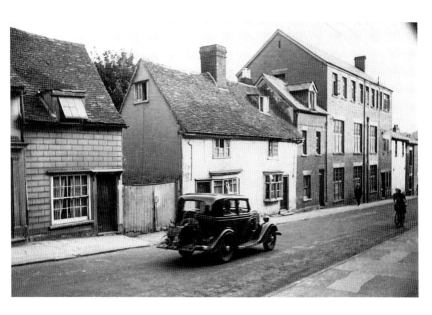

Above: Cottages in Church Street, 1956.

Right: Demolishing the maltings in Barnard's Yard, Church Street, 1974. Barnard Brothers, Coal and Corn Merchants, were founded in 1854 and became a household name in Saffron Walden until they ceased to operate on this site in the early 1970s.

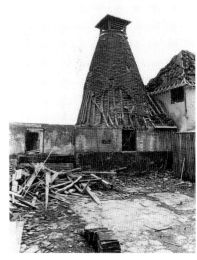

Left: Dorset House, Church Path, a few years before it was demolished in 1957. It was once the home of Joseph Bell, a former mayor, and later became the headquarters of the Territorials. Now a tiny public garden stands on this site.

Below: The Rectory in 1985. Soon after this picture was taken it was sold and it is now the surgery of a Group Practice of local doctors.

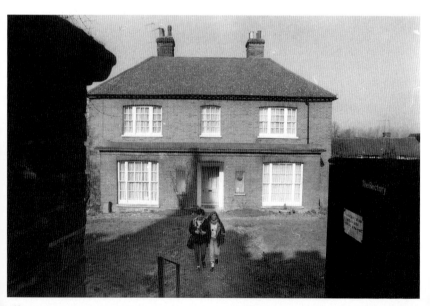

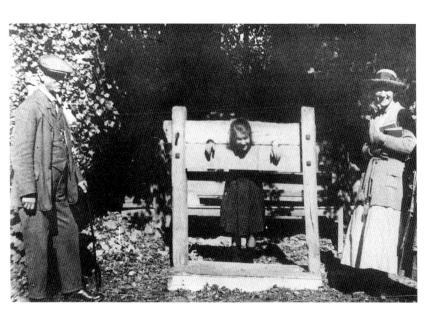

Above: Miss Mollie Trigg in the old Newport Pillory in the grounds of the Castle, *c.* 1920. Her brother, Henry Trigg, is standing to the left and her sister on the right. The Pillory now stands in the Museum's local history gallery.

Right: Mrs Nan Sillett and her baby daughter outside their bakery at 4/6 Castle Street, 1911. Because it stood next door to the Wheatsheaf public house, to the left of this picture, it was called the Wheatsheaf Bakery. Both are now private residences.

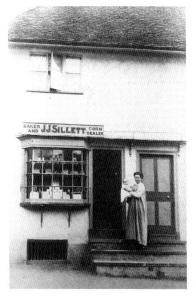

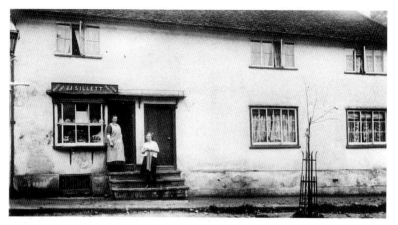

A 1920s picture of Nan Sillett and her daughter outside their bakery. Silletts made a type of bread roll called a "puff" which was highly prized for breakfast by local people. Split and spread with dripping and eaten hot from the bakery, they were said to be absolutely delicious. The business closed during the Second World War.

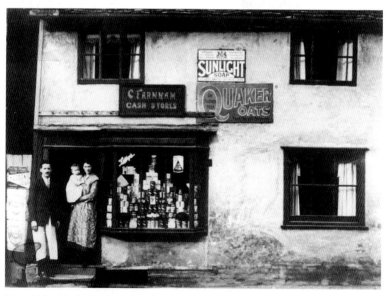

Mr and Mrs Charlie Farnham with their daughter Julia standing outside their grocery stores at 73 Castle Street in 1914.

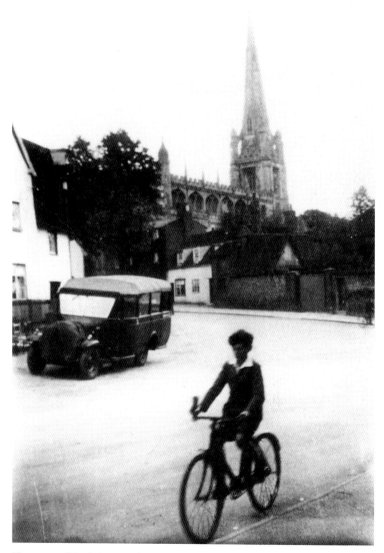

The corner of Castle Street and Museum Street, 1930. The boy on the bike is the Farnham's son, David. He became a bomber pilot in the second World War and was killed in April 1942.

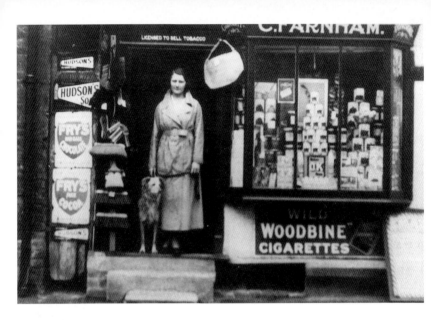

Above: Janet Farnham outside her father's shop, *c.* 1934. Janet later became Mrs.Tom Tinnion. Pete the dog lived for 21 years.

Left: Winifred and Jean Reed outside No.41 Castle Street 1930. The Reeds were a wellknown Castle Street family who ran an antique business (See page 58).

Opposite above: The High Street, *c.* 1900 before the trees were planted.

Opposite below: Lower down the High Street, *c.* 1900 showing the Cross Keys public house on the extreme right before the timbers were exposed. The timbers were exposed about 1910. The Georgian house on the extreme left was demolished in 1934 to make way for the Co-op.

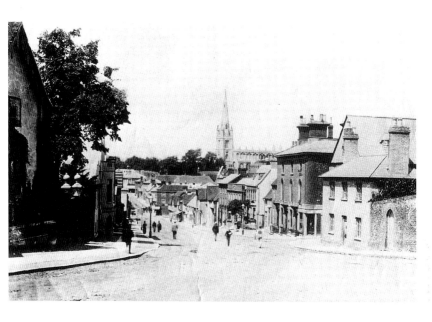

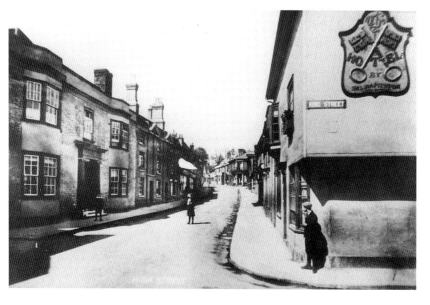

The High Street in 1905 with the trees which were planted in 1902.

The High Street in 1924 showing the Cinema which was built in 1912. The Cinema was demolished in the 1970s along with the cottage next door to make way for a block of flats.

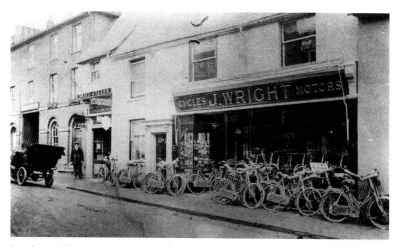

Joseph Wright's shop, c. 1900. Joseph Wright was a cycle agent who later turned to selling cars. His business was bought by Mr "Bill" Raynham and partners in 1917. Raynham's later moved across the road and now Woolworths stands on this site (See page 113).

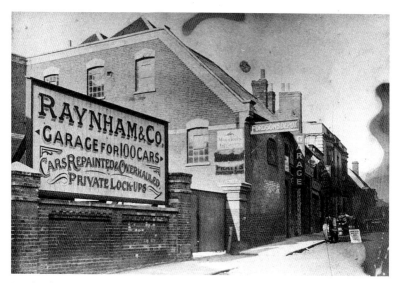

Raynham's in the 1920s. Bill Raynham and partners bought Jabez Wyatt's old brewery intending to sell tractors, but saw the future trend and sold cars instead. It is one of the few family businesses remaining in the town today.

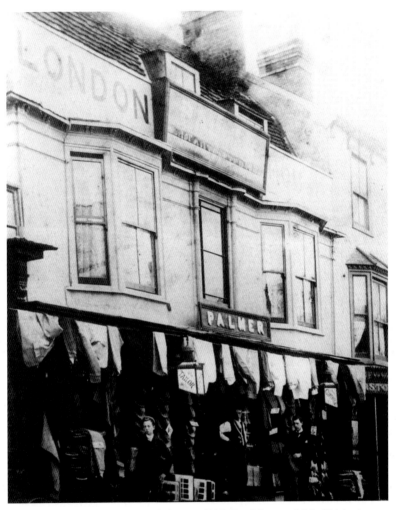

Gray Palmer's London Stores, 47 High Street, c. 1905. Gray Palmer established his business in 1887 in Debden Road to sell clothes for working men. He moved to No.47 High Street at the turn of the century. The business is now run by his grandson, Mr. Richard Gray Palmer and looks very different, catering for the young and trendy of both sexes while retaining good, old-fashioned courtesy.

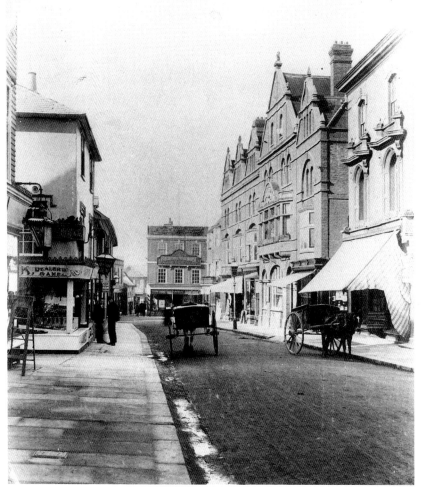

King Street, *c.* 1900. Hardwicks the fishmongers, on the left, was established 1800 in Market Hill and moved to 9 King Street in 1872. They closed in the late 1980s. On the extreme right is the striped sunblind of Charles Spurge's drapers shop, bought by Mr and Mrs Derek Booth in 1946, and sold in 1983 (see page 78).

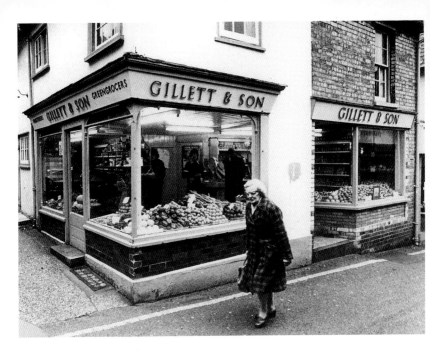

Above: Gillett's greengrocers at No.9 Cross Street, established in 1883 in a tiny shop across the road from No.9. They closed in 1987, and the shop is now an estate agents (see page 56).

Left: This is an advert for Hayward's drapers shop at No.1 Cross Street, which became the Employment exchange in the 1930s, and the Ministry of Labour during the Second World War. It was also Mr. Parrett's "bombed out shop". Mr. Parrett specialised in a miscellaneous stock of goods obtained from shops which had been "bombed out" during the blitz.

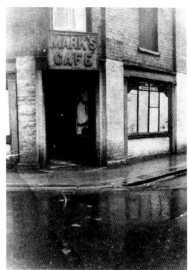

Right: Mark's Cafe during the 1940s. This was later to become Miller's bakery, which is now Dorringtons (see page 69).

Below: Mr. Charles Hagger standing outside his antique shop at Nos. 2 & 3 George Street, *c.* 1900.

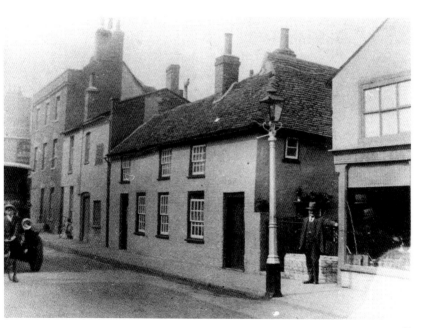

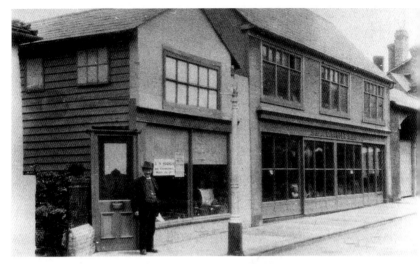

Mr. Hagger displaying his wares on the pavement outside his shop.

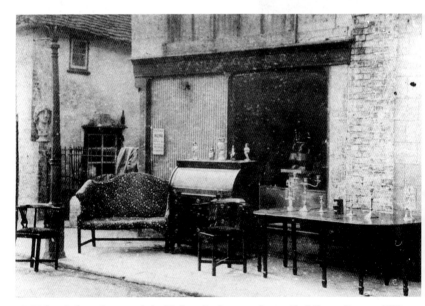

Mr. Hubert Bell standing outside his blacksmiths shop next door to No.6 George Street. c. 1920.

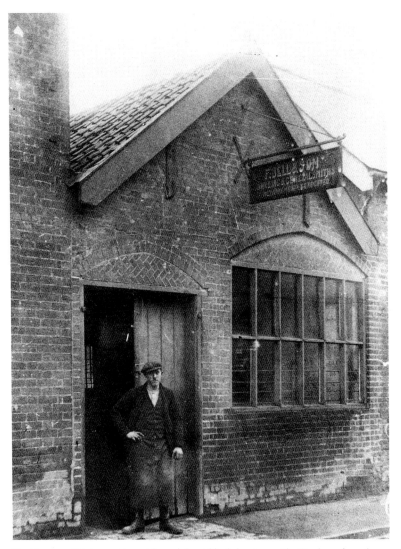

The George public house, the smithy and the stables belonging to The Greyhound, on the corner of George Street and High Street, were demolished about 1962 to make way for a parade of shops.

Left: Mrs. Emily Overall, landlady of the Sun public house in Gold Street, watches the men digging the drains for the new sewage scheme, 1910.

Below: Dolphin House, Gold Street, *c.* 1920/30. The Dolphin inn stood in Market Place where the Tourist Information Centre is today. The sign was moved to No.6 Gold Street in 1761 when the Town Hall was built. The inn is believed to have beeen a seventeenth-century coaching inn, but it is not known when it ceased to be a public house (see page 70).

Opposite above: Fred and Florrie Rushmer standing outside Saffron Walden Laundry in the 1930s. The Rushmer family have lived at Dolphin House since the 1920s.

Opposite below: Inside the Public Swimming Baths in Hill Street, 1980.

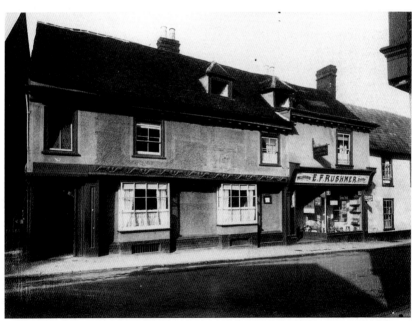

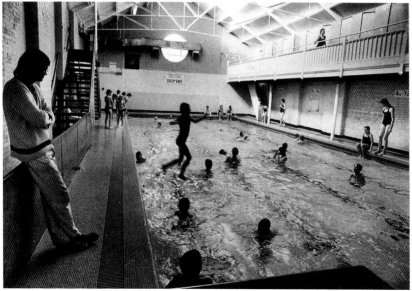

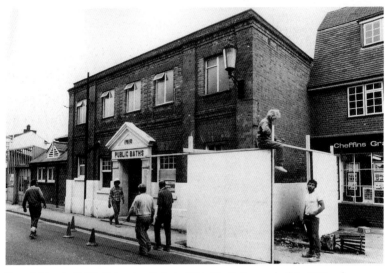

Demolishing the Public Swimming Baths in 1984. The Baths were built in 1910 and were closed in 1982 because it was believed the culvert beneath had become unsafe. This was the begining of the massive redevelopment of Hill Street which included the demolition of the old Pig Market (see page 10).

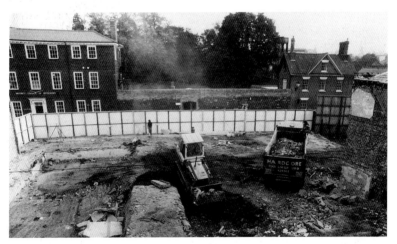

Completion of the Baths' demolition. At the back on the left can be seen the old Council offices, which are now a coffee shop, art gallery and photo copying office. The Day Centre can be seen at the back of the photo on the far right.

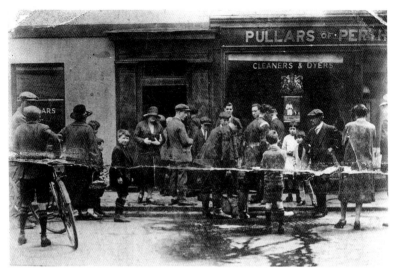

Market Row after the fire at Pullers of Perth in the 1920s.

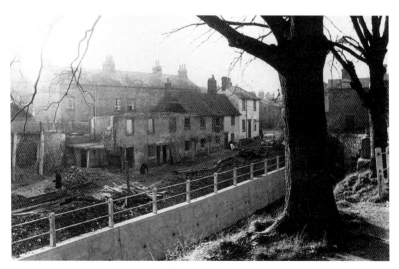

Demolition of the cottages at Cates Corner, 1955. The cottages were due for demoliton in 1939 under the local slum clearance act, but were saved to house evacuees during the London Blitz in the 1940s. The Police Station car park is now on this site. The trees in the foreground on the right are on the Common.

The gardens of Fairycroft House in the 1930s. This is now the site of the Social Services and a car park. Fairycroft House was built 1830/1831 for Charles Fiske, a local surgeon. After being occupied by several wealthy people it ceased to be a family home in 1935. It remained empty for a long time until it became the A.R.P. Centre for the town during the Second World War. Now it is an Adult Education Centre and Youth Employment Office.

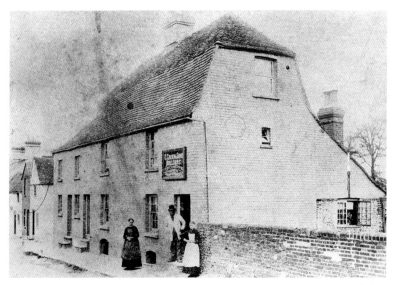

Thaxted Road, Nos. 18, 20 and 22, c. 1890. Elijah Green, the master builder, stands outside his premises.

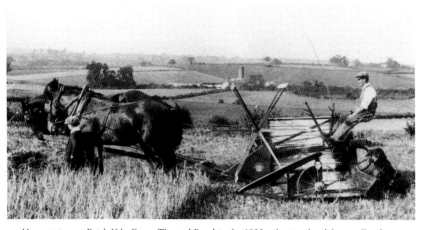

Harvest time at Brick Kiln Farm, Thaxted Road in the 1920s, showing local farmer, Frank Wiseman and his dog. The old Cement Works can be seen in the distance in the centre of the photo. The Works were opened in 1897 and produced 5,000 tons of cement a year until 1920 when the Works were closed down. The land to the left of the picture is now occupied by houses, whilst the extreme left is now Shire Hill Industrial Estate.

In the stackyard at Brick Kiln Farm in the 1920s.

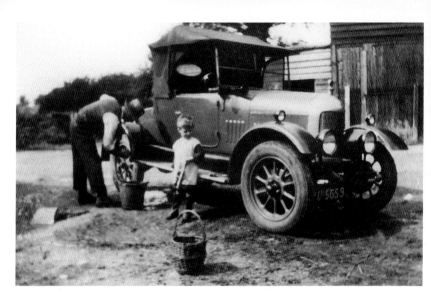

Above: Frank Wiseman washing his car watched by his son David, about 1920. David is the third generation of Wisemans to farm Brick Kiln Farm.

Left: Prospect Place, Thaxted Road, in the early 1930s. It has changed very little since this photo was taken.

Opposite above: The Gate public house in Thaxted Road, *c.* 1950, when it sold Rayments Pelham Ale. On the far left is a glimpse of the railway bridge, which was demolished in the late 1960s.

Opposite below: Stanleys Farm House, Thaxted Road, just before its demolition in 1985 to make way for houses. It was not a particularly attractive building, but most of Shire Hill Industrial Estate is built on land belonging to Stanley's Farm.

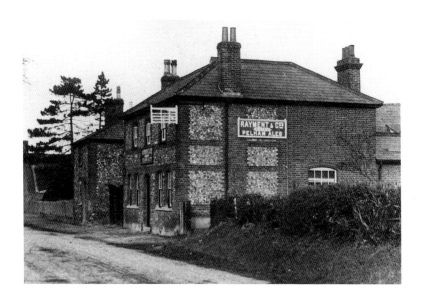

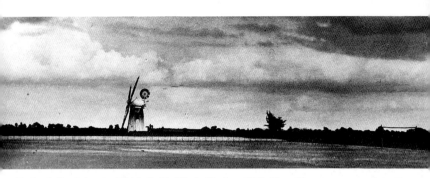

Peaslands Road showing Middleditch's Windmill, about 1895. The mill was an octagonal smock mill, erected in 1799, on two acres of freehold land. It was first owned by a miller called Cane, but was later sold to William Middleditch in 1821 who worked it up to his death in 1850. Afterwards it passed through various hands until it was severely damaged by a gale in the late nineteenth century, and was eventually demolished in 1898.

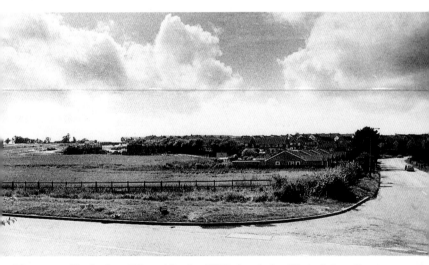

The corner of Peaslands and Thaxted Road, c. 1970 before the Lord Butler Leisure Centre was built.

Opposite above: Debden Road in 1932. The girl with the pram is young Margaret Smith (now Mrs Fred Warner) on her way to the Horticultural Show.

Opposite below: Debden Road Garage and shop about 1950.

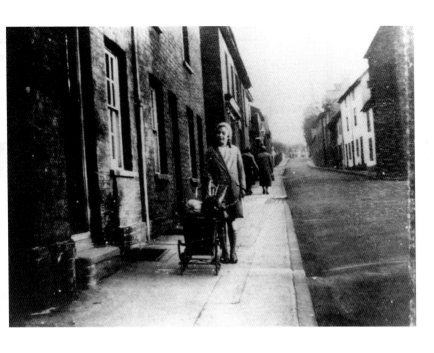

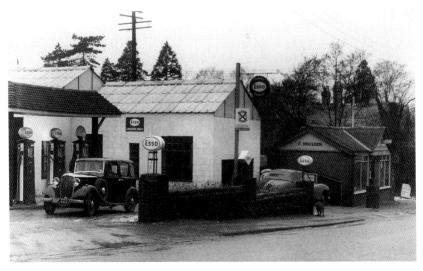

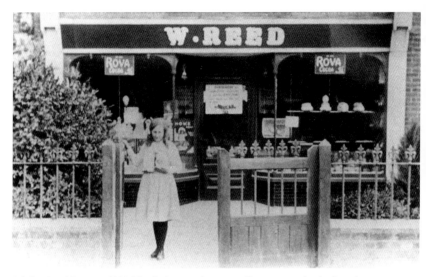

Ashdon Road Stores, *c.* 1920. This little general store is still in existence but looks rather different these days.

Radwinter Road showing the Talbot Press, *c.* 1950. The Talbot Press was founded in the early 1920s by the late Richard Wood and stood here until it merged with the local printers, W. Hart and Son in 1974 and became HartTalbot Printers (see page 68). This building was demolished in the late 1980s to make way for new houses.

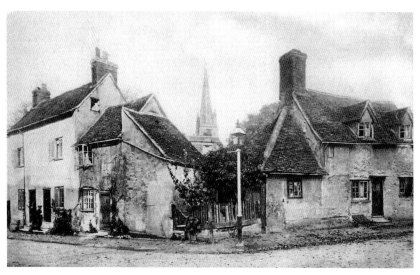

Myddylton Place in the late nineteenth century.

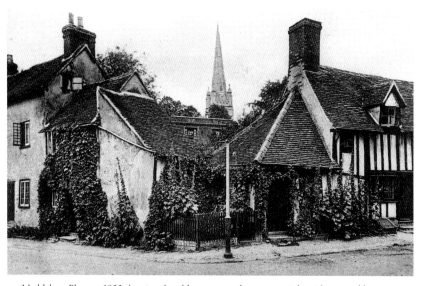

Myddylton Place, c. 1900 showing the old cottage on the extreme right with exposed beams.

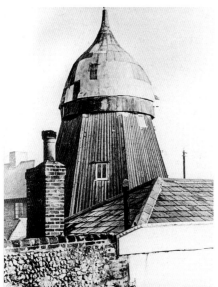

Above: Swan Meadow, 1984. This was the last piece of rural Walden in the heart of the town before it was destroyed to make a car park in the early 1990s. Controversy raged for many years over the project, and even today, many people will not use the car park because they feel the meadow should have been left as it was.

Left: South Road, *c.* 1950, just before the very last windmill in the town was demolished.

Two

Old Family Business

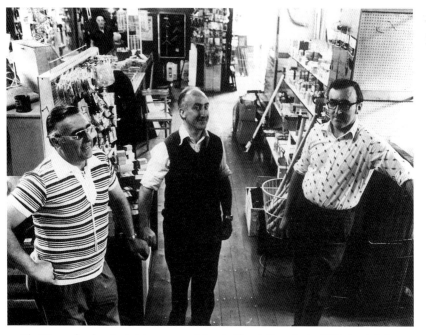

The Vincent brothers in their ironmongers' shop in Church Street in the 1970s shortly before the business closed. There never was a shop quite like Vincent's, you could buy one nail or a pound of nails, nothing was prepacked.

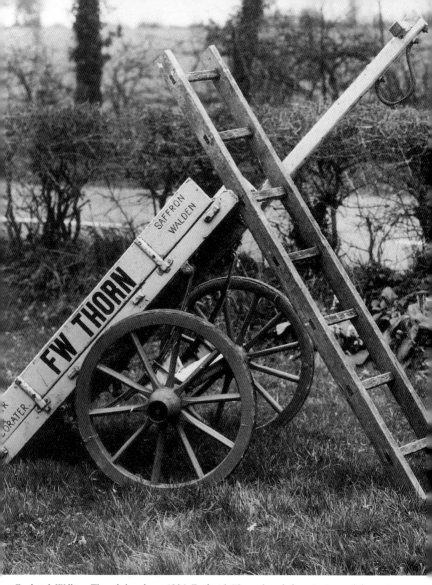

Frederick William Thorn's handcart, 1906. Frederick Thorn founded a painting and decorating business which lasted almost 90 years.

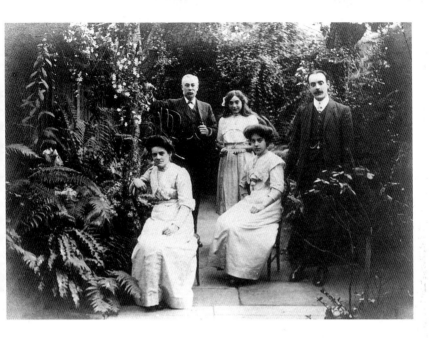

Above: Frederick William Thorn, centre, his wife Sarah, seated left, and daughters May, seated, Maud standing, and Lewis his son, in their conservatory behind the shop at No.11 Hill Street, *c.* 1911.

Right: Thorn's shop decorated for the coronation of George VI.

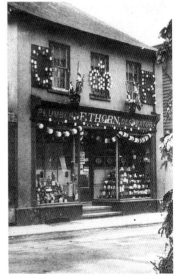

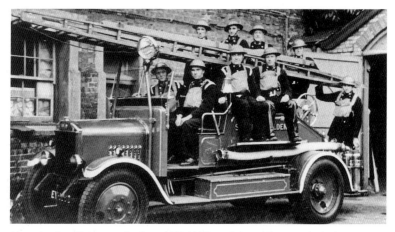

Above: Auxiliary Firemen in the Second World War with Lewis Thorn, at the back, centre right.

Below: The late Bill Thorn (Lewis's son) in 1980 with Miss Barbara Mizen holding a sample in the background.

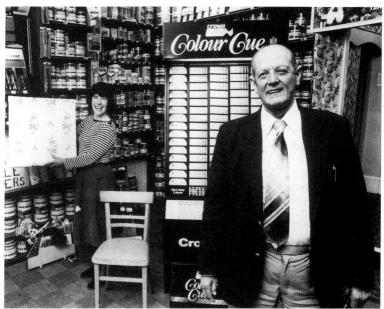

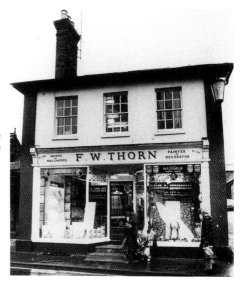

Right: Thorn's shop at No. 11 Hill Street, 1980. Five years later it was demolished to make way for a Waitrose store and Thorn's were given a new site close by. The business closed in 1992 after the sudden death of Mr. Charlie Hutchings, May Thorn's son.

Below: The Snowflake Laundry van decked for the Carnival in the 1920s. The Snowflake Laundry in Castle Street was owned by the Adams family for 60 years. In 1968, the business was sold to the Saffron Walden Laundry company in Gold Street.

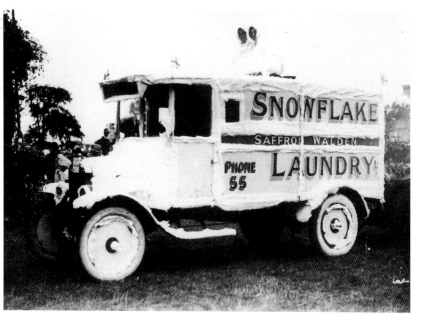

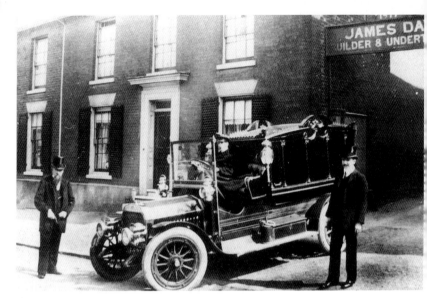

Above: Undertaker James Day and his nephew Herbert Peasgood outside their Funeral Parlour in Gold Street, *c.* 1900. James Day established his business in 1847 in a cottage in the High Street, now the site of the Friends' Meeting Room. The Friends gave him £100 to build a new workshop in Gold Street.

Opposite: Herbert Peasgood's grandsons Jack, centre right and Alan, right, and great-grandson David. The Peasgoods moved their business to Shire Hill in 1994, to make way for a block of flats.

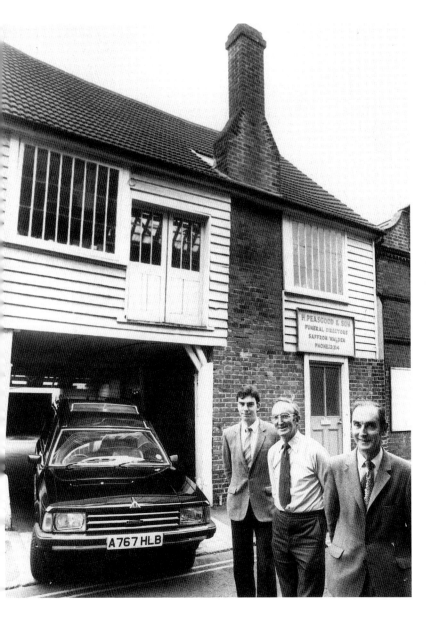

Arthur Gillett, grandson of David Gillett with Dougal the horse (named after the Clavering murderer, see page 106), c. 1903. David Gillett founded the family greengrocery business in 1860 (See page 32).

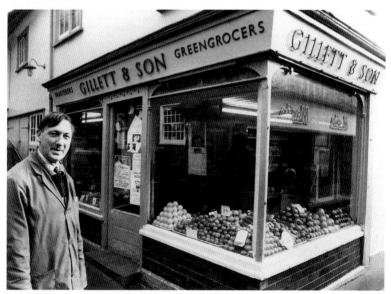

Maurice Gillett, Arthur's son, outside No.9 Cross Street in 1986. They bought this shop in the late 1880s and the family ran it until April 1987 when Maurice retired. It is now an Estate Agents.

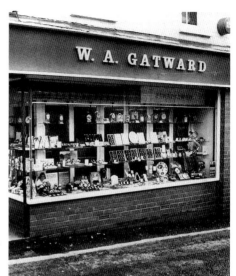

Right: William Arthur Gatward's jeweller's shop in Cross Street in the late 1970s. The business was founded over 200 years ago and run by five generations of Gatwards until it was sold in 1978.

Below: Hardwick's fishmongers in King Street, with the manager Steve Anderson in the foreground, 1984. Hardwicks stood on this corner from 1872 until it closed in the late 1980s. It is now Burton's, the butchers.

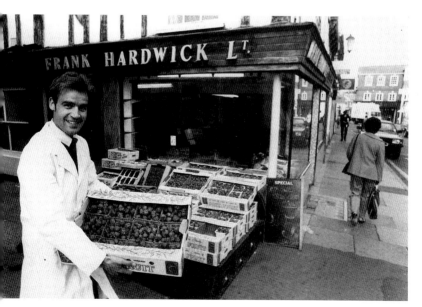

Right: Thomas and Alice Reed in the late nineteenth century. Thomas opened his antique shop in Castle Street in 1881. It is still there today and is run by his grandson Clifford Reed and Clifford's son Martin.

Below: Clifford Reed, centre, and his brother, the late Kenneth Reed, right, in their antique shop, 1981.

Opposite above: Mr. Richard Goddard, on the right, in the family butchers' shop in Church Street, with assistants Terry Start, centre, and Adrian Robertson, left. The business was founded by Richard's father, Tom, in 1922. Tom ran it in partnership with his brothers, George, Stanley and Reg. Later it was run by Richard and his brother Norman, until they retired in the late 1980s. Goddard's were famous for their sausages.

Opposite below: Men at Verts Nurseries in Fairycroft Road, 1912. The foreman Ernest Robinson is centre left, Jeff Searle, centre right, Ted Linwood, left. Newcroft and Four Acres, sheltered accommodation for the elderly, now stand on this site.

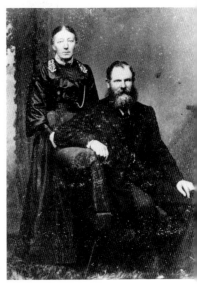

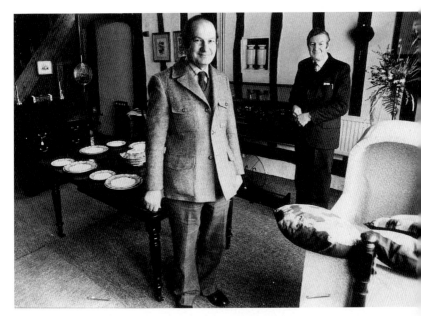

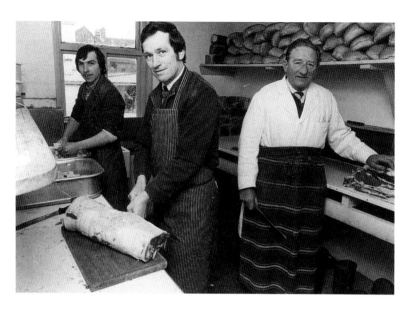

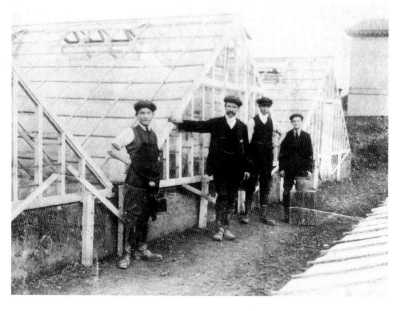

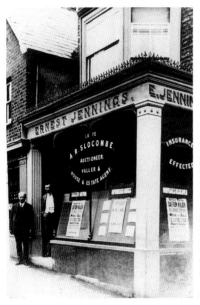

Left: The late Ernest Jennings, well-known auctioneer and estate agent, outside No.5 Cross Street soon after he bought Mr. Slocombe's business in 1906. He later moved to No. 13 King Street, now Talents Gift shop.

Below: Ernest Jennings with his assistant, Roy Fisher, conducting an auction in the Corn Exchange in the late 1940s. These auctions were extremely popular during the Second World War when furniture and other household items were in short supply. Ernest Jennings died in 1956.

Opposite below: One of Ernest Jennings' posters.

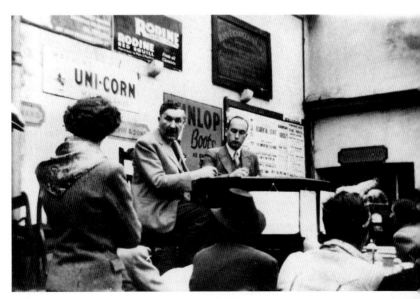

WITH POSSESSION.

SAFFRON WALDEN & ASHDON

Within 2½ Miles of Saffron Walden Station.

MR. ERNEST JENNINGS

Has been favoured with instructions from the Owner, to Sell by Auction at the

Committee Room, Town Hall, Saffron Walden,

On Tuesday, August 12th, 1919,

At 4 o'clock precisely, in 3 Lots, THE VALUABLE

FREEHOLD PROPERTY

KNOWN AS

"EVERETTS FARM,"

Pleasantly situated at Seward's End, comprising Brick and Tile-built FARM HOUSE, useful FARM BUILDINGS, GARDEN and PADDOCK, also

2 ENCLOSURES OF

PRODUCTIVE ARABLE & PASTURE LANDS

Situated on the Road from Seward's End to Roth End and Ashdon, comprising in all about

38 ACRES.

Particulars and Conditions of Sale may be obtained of

Messrs. R. VOSS & SON, Solicitors, Post Office Chambers, 173 Bethnal Green Rd., London, E. 2.

And of Mr. Ernest Jennings, 3, Cross Street, Saffron Walden and Thaxted.
TEL No 29.

HART & SON, PRINTERS, KING STREET, SAFFRON WALDEN.

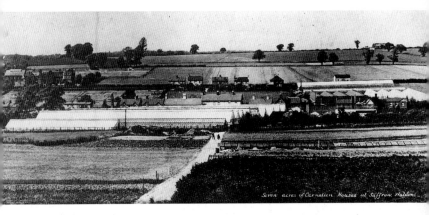

Seven acres of Carnation Houses at Saffron Walden

Seven acres of glasshouses at Engelmanns' Nurseries in the 1920s. In the foreground, is Radwinter Road whilst Ashdon Road can be seen in the background. The Grammar School, now Dame Bradbury's School is at the top left hand side. German-born Carl Gustave Engelmann came to Saffron Walden in 1897 and started his nursery with one tiny greenhouse and packing shed in Radwinter Road. When his son Eric retired in the 1970s, his nephew Paul Engelmann closed the business down.

Opposite above: New boilers at Engelmanns' Nurseries, 1947.

Opposite below: Mark Salmon's Stores in Castle Street 1981. This shop was run by members of the Salmon family from 1908 until 1994, and hardly changed in that time.

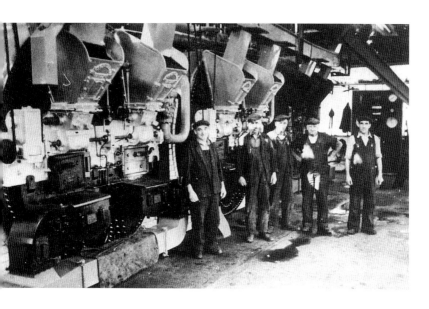

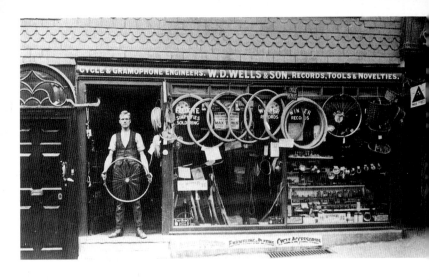

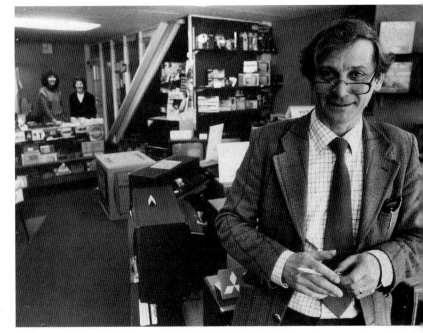

Left: Barclays Bank, *c.* 1970.

Below: Interior of Barclays Bank, *c.* 1900. The Gibson family, prominent Quakers, established the Saffron Walden and North Essex Bank in 1824 and amalgamated with Barclays in 1896 (see page 11).

Opposite above: Mr. Wells' shop at No.25 High Street in 1918. Mr. Wells bought the business in 1915 and later, his son ran it until 1934 when it then became Radio Supply Stores.

Opposite below: Mr. John Jacobs of Radio Supply Stores which he ran with his wife, Parma, and his brother, Gordon. John Jacobs entered the business as a service engineer in 1950. Radio Supply Stores closed early in 1994.

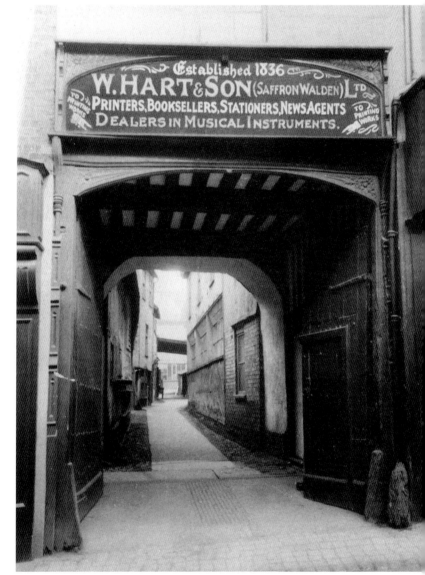

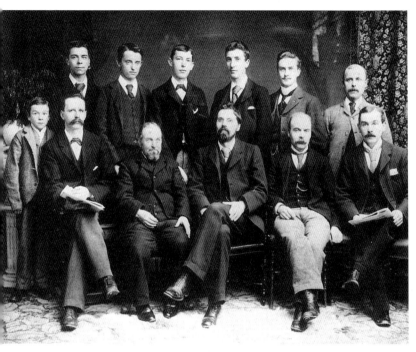

Henry Hart's grandson Erwest (seated centre left) with his employees in the late 1900s.

Opposite: Entrance to Harts' printing works in King Street, *c.* 1920. The business was established by Henry Hart in 1836 and run by three generations of Harts until it was sold to their manager, Edwin Turnbull. Later Edwin's sons, Jack and Angus, split the business into a printing works and a book shop. Harts Books in King Street is still run by Angus Turnbull and his family (see page 46).

Left: Harts' advertisement in the Saffron Walden Weekly News, Friday 6 March 1896.

Below: Harts printing works in King Street, 1964, just before moving to Shire Hill. They later amalgated with the Talbot Press in Radwinter Road (see page 46).

Opopsite above: Miller's bakery at No.14 London Road, This bakery was established in 1891 in Park Lane and transferred to these premises a few years later. It was run by three generations of the Miller family until it closed in 1991. They also opened another shop on the corner of Cross Street in the 1950s (see page 33).

Opposite below: Choppen's garden and agricultural machinery shop at No.15 George Street in the 1960s. Albert John Choppen established this business in the late 1890s. Three generations of Choppens ran it until it was sold to Chater & Myhill who later moved the business to Thaxted Road around about 1984. Choppen's became a victim of the recession and closed in the early 1990s.

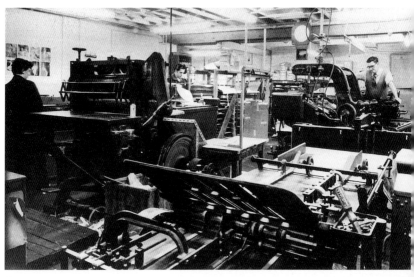

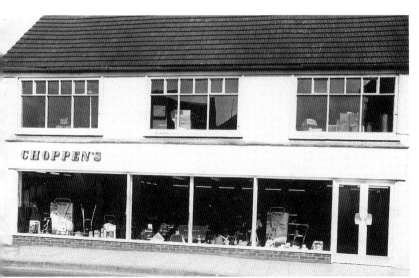

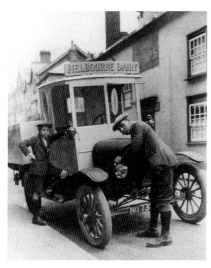

Left: Dairyman, Ernest Rushmer senior, with his son, outside the Hoops public house in King Street. Ernest Rushmer, of Gold Street, had a flourishing milk round in Saffron Walden during the 1920s (see page 36).

Below: The late Sam Mitson, signwriter of Gold Street, with young Len Rushmer, in the 1920s.

Opposite above A Somerlite travelling shop in the 1920s. Somerlite travelling shops were owned by the Sizer family in Walden and were a familiar sight in and around the town from 1925 until 1969.

Opposite below: A Somerlite travelling shop parked on Church Hill, Ashdon, 1920.

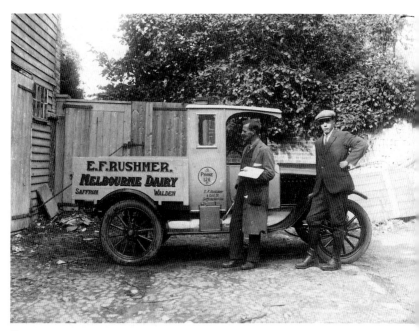

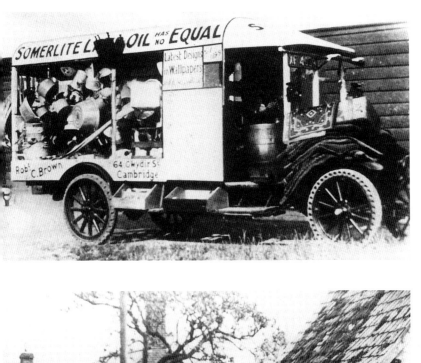

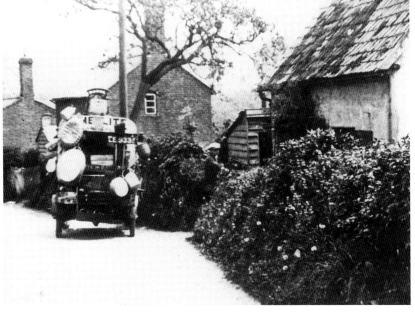

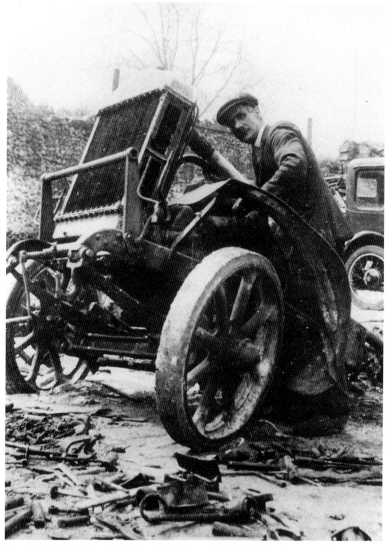

Tom Harris in his scrapyard in Thaxted Road around 1920/30. Tom was a travelling showman who "pulled in" with his family on Swan Meadow during the winter months before the First World War. After being severely gassed during the war, he settled in the town and ran a scrapyard.

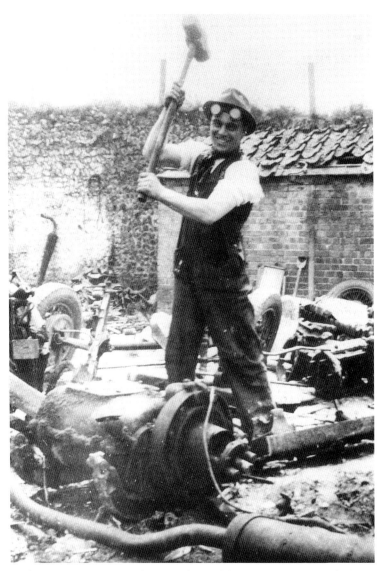

Tom's son, George, working in the scrapyard around about 1935. George married Elsie Jarvis, a local girl who became mayor twice, mayoress once and was ultimately made a Distinguished Citizen in 1987.

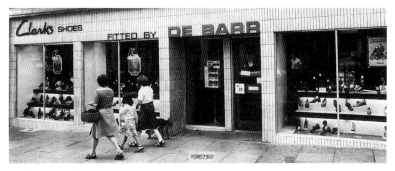

DeBarr's shoe shop in the High Street, in 1979. The shop was opened in 1915 by the late Walter DeBarr, a chiropodist. It was run by the DeBarr family until the late 1980s when it was sold to Buckingham's.

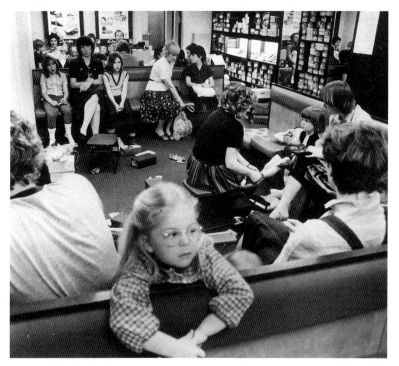

Inside DeBarr's children's department 1984. A visit to DeBarr's was a must for every schoolchild in Walden.

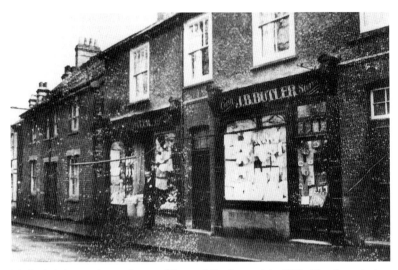

Mr. Butler's drapers shop at the top of Fairycroft Road around the 1920s. This shop, which is now an antique shop, sold wool and ladies' drapery from the early 1920s until the late 1960s.

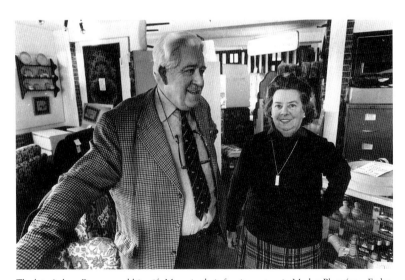

The late Aubrey Rumsey and his wife Mona in their furniture store in Market Place (now Eaden Lilley) in 1981. Rumsey's came to the High Street in Saffron Walden in 1954 and moved to Market Place in 1964. They closed in 1985 when Mr. and Mrs. Rumsey retired (see page 11).

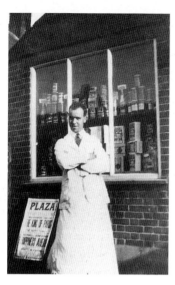

Left: The Coop in Victoria Avenue, in 1937, with the manager, Mr Len Reed standing outside. The films advertised on the board outside are, "The King of Paris" and "Happiness Ahead."

Below: The new Coop in Castle Street, 1951. This was built on the site of the Snowflake Laundry (see page 53). No longer able to cope with modern shopping habits, the Castle Street Coop closed in the early 1980s.

Opposite above: Mr Leslie Penning, on the left, and his brother Jim inside their grocers' shop in Market Place, August 1980 (see page 14). The business was started by their father, Francis Penning, around 1918, and continued until 1986, when the Penning brothers retired.

Opposite below: When Penning's closed it was an end of an era for Saffron Walden, and was recorded by Anglia Television.

NEW BRANCH SHOP
CASTLE STREET, SAFFRON WALDEN
Opened September 1st, 1951

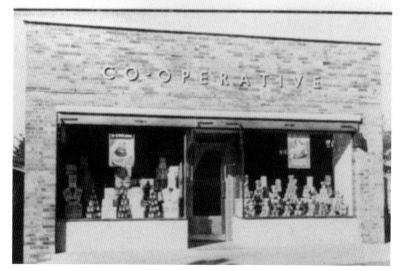

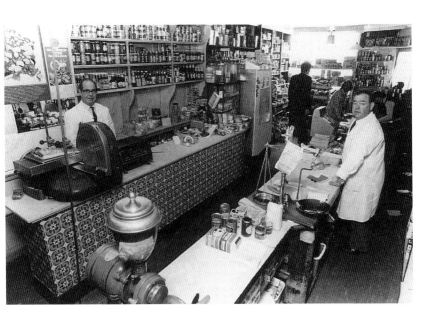

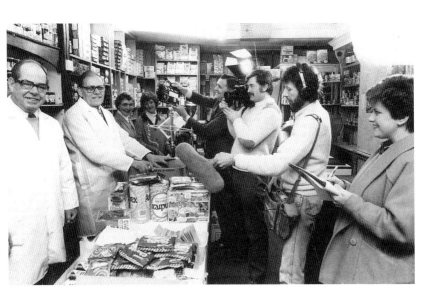

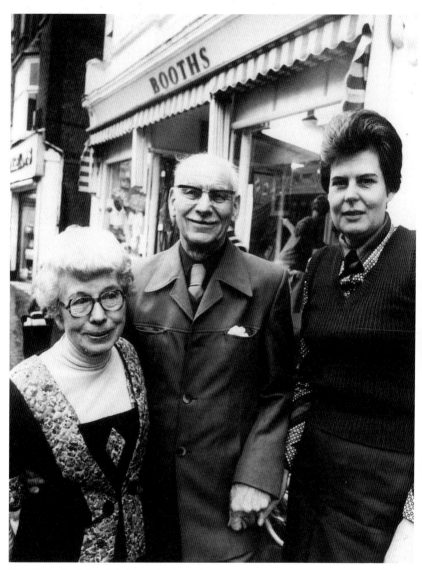

Mr and Mrs Derek Booth and their daughter-in-law, Veronica, outside their drapers shop in King Street, October 1980. They bought the shop from Mr. Charles Spurge in 1946 and sold it around 1983 (see page 31).

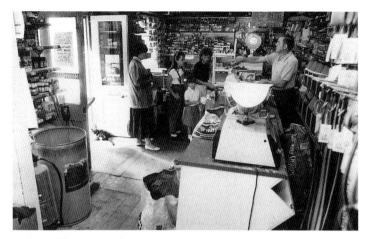

Inside Gould's pet and garden supplies shop in Market Row, 1987. Gould's opened here in the late 1920s as seedsmen, and the interior has changed very little since then. The business was sold to the Wood Green Animal Shelter in the late 1980s or early 1990s.

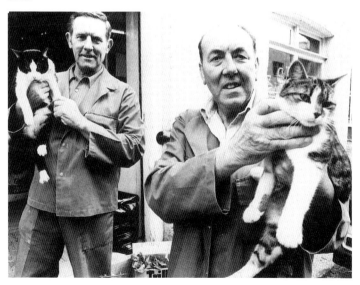

Dick Cornell, on the right, and his brother Arthur who ran Gould's for many years. They are photographed here in 1981 with the famous shop cats Tiddles and Toddles. People would make a point of visiting Gould's just to see the cats.

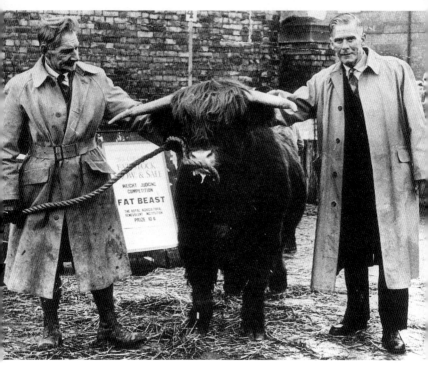

The late Herbert Warner, on the right, with cattle market assistant Mr. Thake and a prize bull at the cattle market in 1958. Herbert Warner was manager of Isaac Marking's butcher's shop on the corner of Church/Museum Streets. The business was established in 1879 and run by the Marking family until 1950. Herbert Warner continued as manager until his sudden death in the 1960s. The shop closed in the early 1980s and is now a china shop.

Three

Schooldays

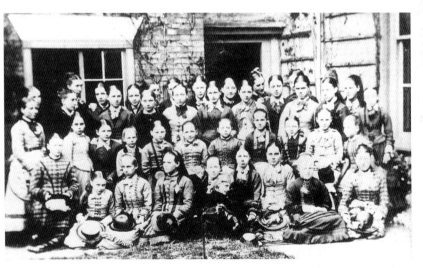

Staff and girls of Cambridge House School, Church Street, 1877. Cambridge House was a select day and boarding school for young ladies, run by the Misses Cowells, who prided themselves on their high principles. It was later taken over by the Misses Gowletts, three formidable ladies who, in the latter part of the 1920s, moved the school to The Grove, a large house (now called Eastacre) on Chaters Hill. The school closed in the early 1930s.

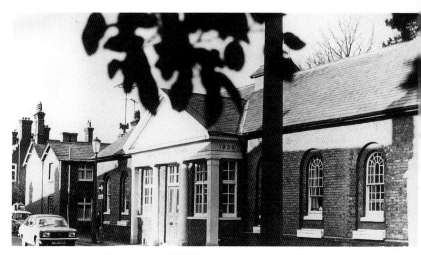

The Boys British School in East Street, 1978. The school was built in 1838 and funded by local philanthropists with the assistance of the British and Foreign Schools Society to educate "children of the poorer classes of all denominations." Parents had to pay twopence a week for the cost of their children's education. Eventually the school became a State school and closed in 1982. After lying empty for a number of years the building was finally converted into offices.

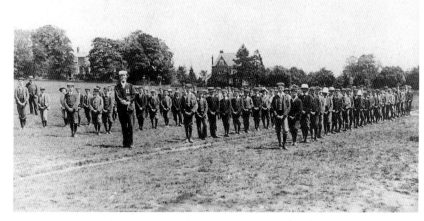

Pupils of the Boys British School being drilled by "Sergeant Holman" on the Common, c. 1900. The large house in the centre background is Hatherley, an opulent late Victorian house built in 1889 for Theodore Scruby a prosperous wine merchant. It is now a residential home for the elderly.

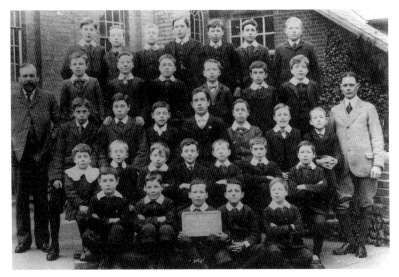

Headmaster Harry Hayes with assistant master Mr Wood and pupils of the Boys British School, 1910.

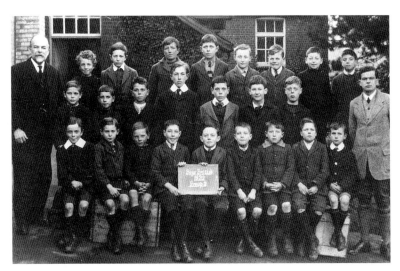

Pupils of the Boys British School 1920.

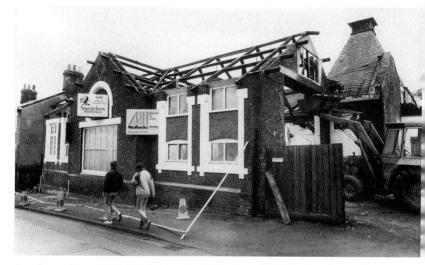

Demolition of the old Girls British School in Debden Road, 1985. The Girls British School started in Gold Street in 1847, and moved to Debden Road in 1852, later South Road in 1902, when it became known as South Road School.

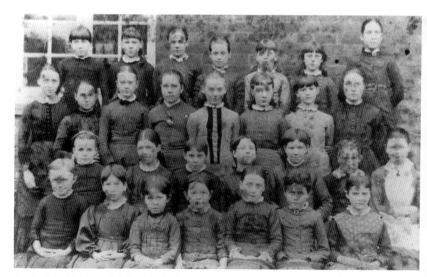

Pupils of the Girls British School, c. 1888.

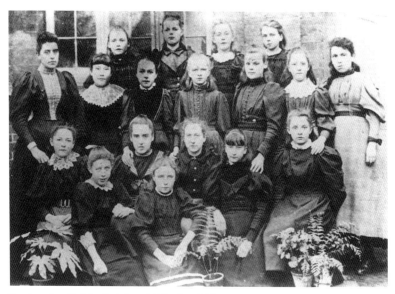

Pupils and staff of the Girls British School, *c.* 1895.

South Road School, the former Girls British School, 1986. This building is now part of the Bell School of Languages.

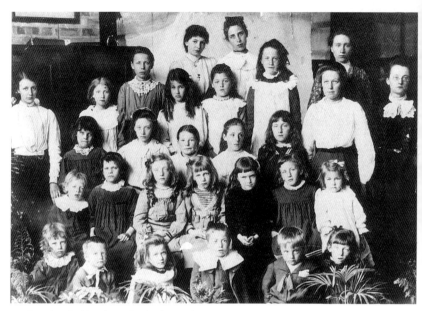

Pupils and staff of South Road School, 1903/4.

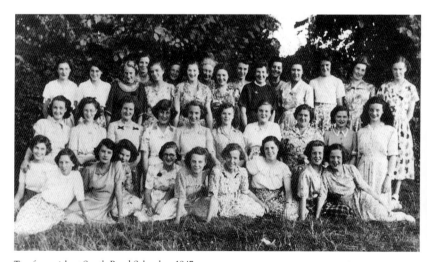

Top form girls at South Road School, c. 1947.

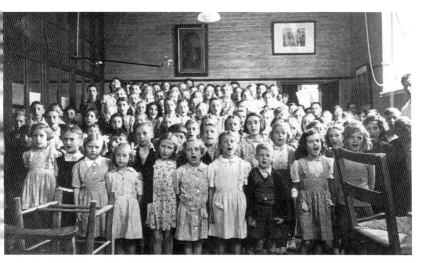

Pupils of South Road School, 1948.

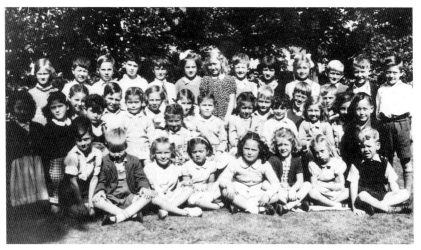

The Infants class at South Road School, 1949.

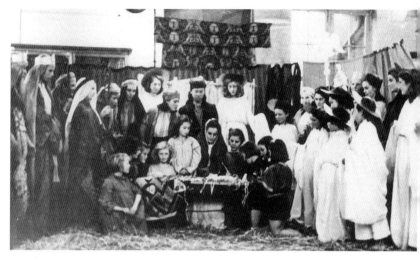

A performance of a Nativity Play at South Road School, 1949

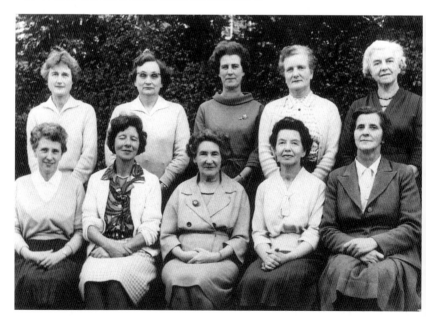

Staff at South Road School in the late 1950s.

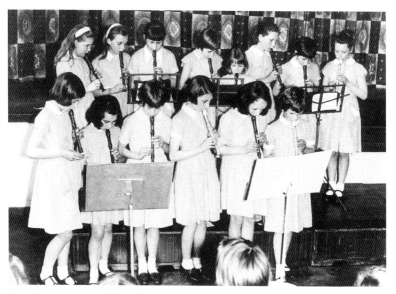

Recorder practice at South Road School, 1964.

Museum Street Infants School in the 1960s. This school was built in 1817 as forerunner of Castle Street School. By 1837, it had become known as the Girls National School, then in 1849 it became the Castle Street Infants School. It is now a lecture room for the Museum. A new house, built in 1994, stands on the site of the old schoolyard.

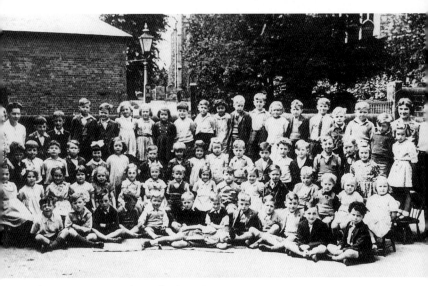

Pupils of Museum Street Infants School, 1946.

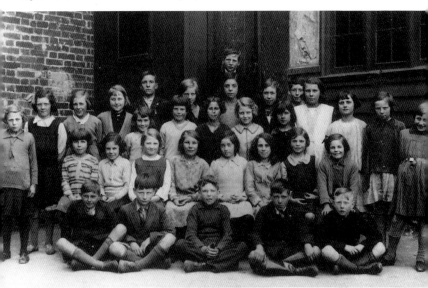

Pupils of Castle Street School, now called St. Mary's, *c.* 1931.

Four

Highdays and Holidays

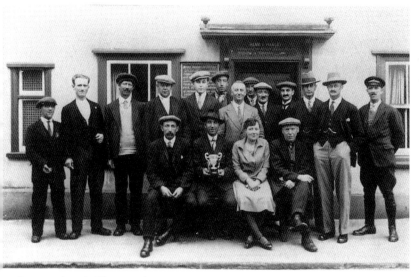

An outing from the Waggon and Horses, East Street, 1932. The man in the peaked cap is Mr Thake.

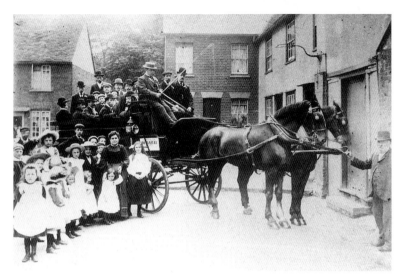

An outing of Saffron Walden Botanical Society leaves Gold Street, *c.* 1907.

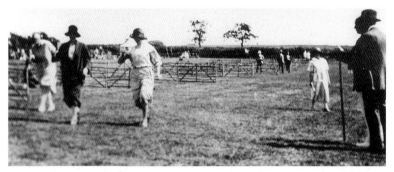

Sports Day at Engelmanns Nurseries on the meadows of Shire Hill in the 1920s (see page 62).

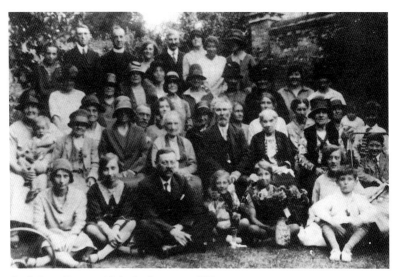

Castle Street Primitive Methodists' outing, *c.* 1920.

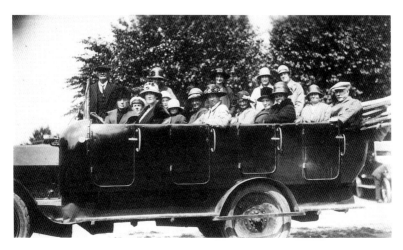

Castle Street Primitive Methodists' outing in the late 1920s. The charabanc belonged to Mr. George Reed, a member of the wellknown Reed family, antique dealers of Castle Street.

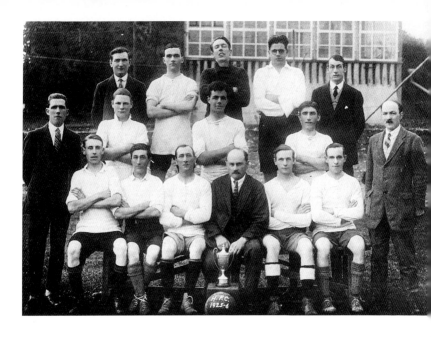

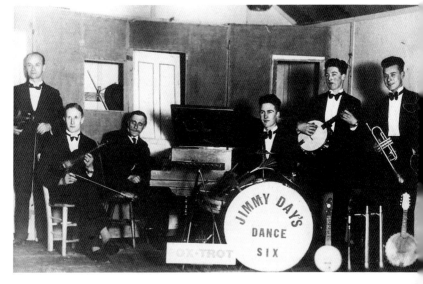

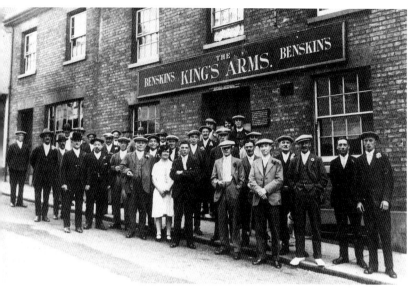

The King's Arms Cork Club outing, early 1930s. Members wore a special tie knitted by the landlord's wife, and carried a cork around with them. If they met another member in the street, one would challenge the other by asking if they had their cork with them. If they hadn't they would be fined usually about three old pennies.

Opposite above: Carl Gustave Engelmann, centre, with Horneybrook Nursery football team in 1925 (see page 62).

Opposite below: Jimmy Day's Dance Six. Jimmy Day and his band played at many a local "hop" during the 1920s and '30s. Don't they look smart!

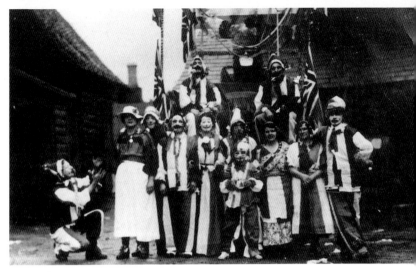

The Cork Club fancy dress party in the yard of the King's Arms in the early 1930s.

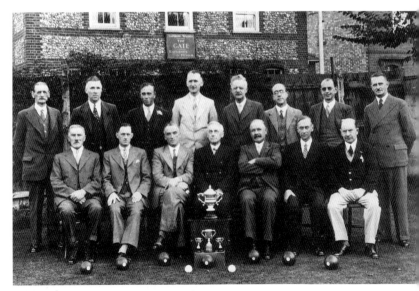

The Gate Bowling Club team, 1935.

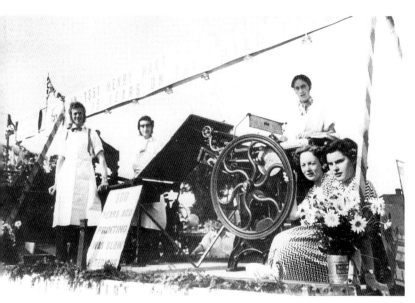

Hart's printing works' Carnival float, 1951. The printing press was 115 years old. The man standing on the left is Mr. Ralph Housden (see page 66).

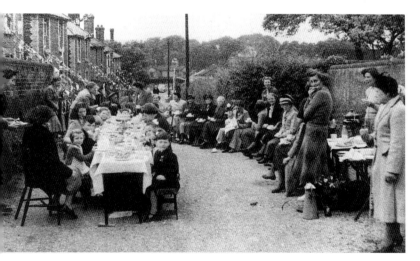

A Street party in Westfields to celebrate the Queen's Coronation, 1953.

A Railway Arms customers' outing, 1954.

The Women's Institute Choir c. 1950.

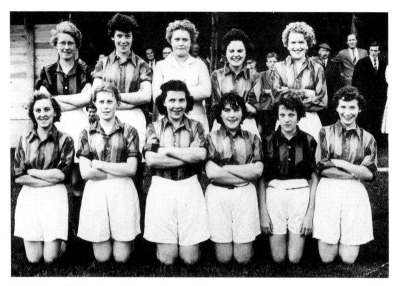

The Saffron Walden Laundry Soccer Team, 1957.

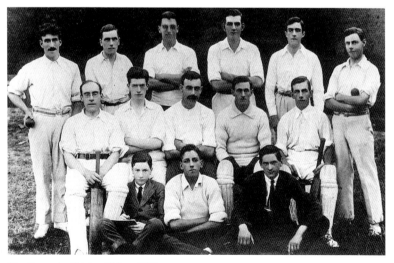

The Comrades Cricket Club, c. 1920.

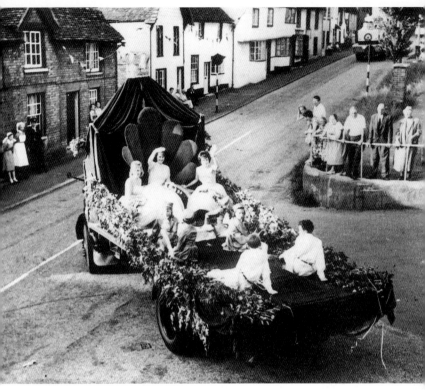

The Carnival Queen leaving Castle Street and just about to enter the High Street, 1961.

Five

Events which made
the News

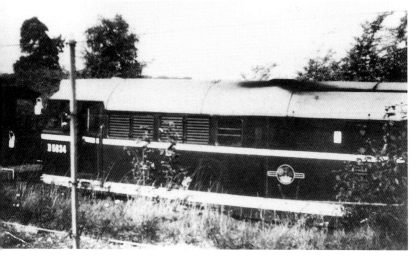

The last train to leave Saffron Walden Station, 1963. Saffron Walden was the very first line to be
axed by Dr Beeching.

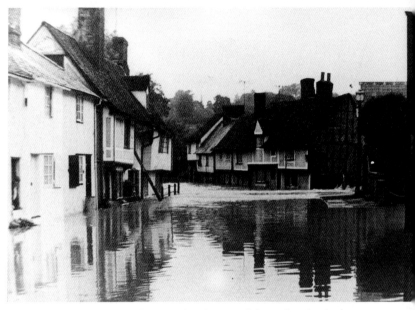

Bridge Street after heavy rain in the 1960s when the River Slade overflowed its banks.

Opposite above: There was great excitment in the town when an aeroplane landed in a meadow near Peaslands Road in 1912.

Opposite below: Crowds inspect the aeroplane. The two people in the very centre of the photograph are Mr Frank Housden and his wife Lydia.

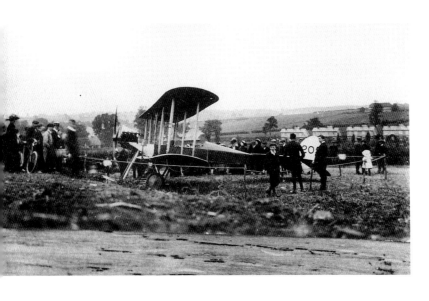

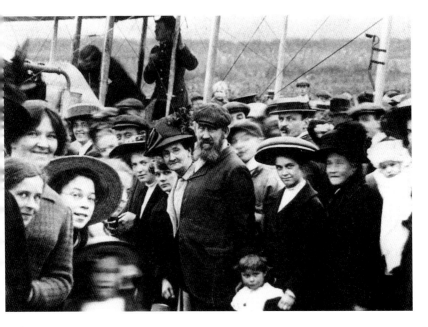

Samuel Herbert Dougal, the Clavering Murderer.

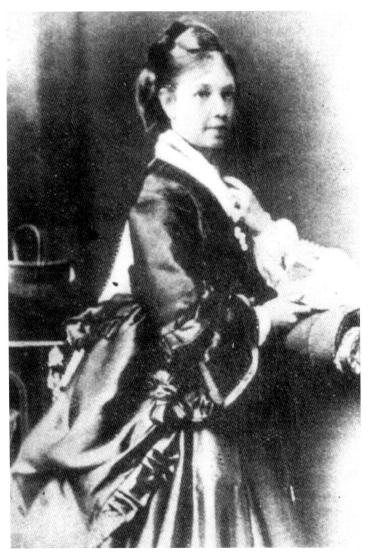

Camille Holland, his 56 year old victim, whom he murdered for her money in May 1899. They met in London and came to Saffron Walden posing as man and wife, although Dougal already had a wife. They lodged in a cottage in Market Row for a few weeks before moving to Moat Farm in Clavering.

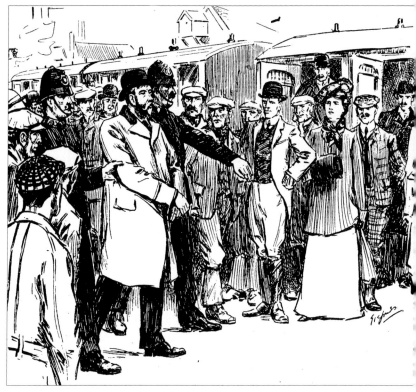

Above: Dougal with police escort at Audley End Station. The murder remained undiscovered until 1903 after people became suspicious of the non appearance of "Mrs Dougal". It was their landlady from the cottage in Market Row who identified the body.

Opposite: The trial of Samuel Dougal. He was found guilty and hanged at Chelmsford Gaol, July 1903.

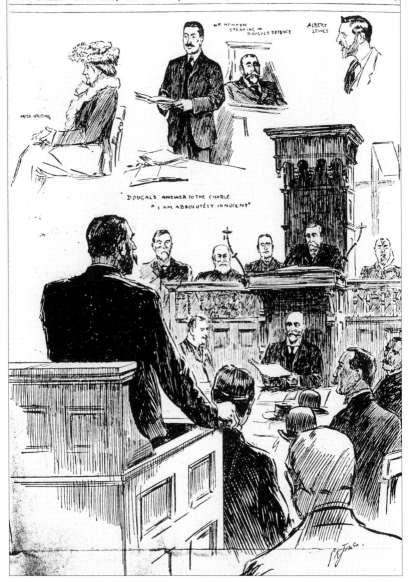

MISS WHITING

MR. NEWTON SPEAKING IN DOUGAL'S DEFENCE

ALBERT LEWES

DOUGAL'S ANSWER TO THE CHARGE "I AM ABSOLUTELY INNOCENT"

Queen Wilhelmina of the Netherlands visiting Miss Elizabeth Sexton Winter, her one time
friend and chaperone, in South Road, September 1935.

Six

Local Personalities

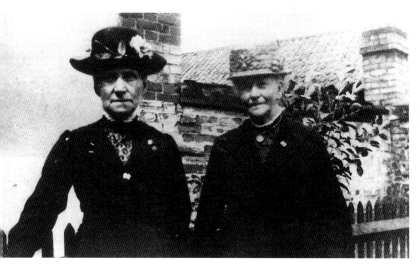

The lady on the right hand side of this photograph is local character, "Gran" Porter, aged about 78. With her is her sister-in-law Harriet Porter. The photograph was taken in the High Street when they were on their way to a Mothers Meeting.

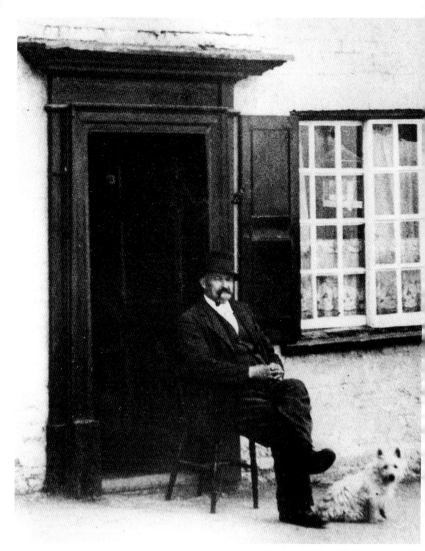

"Navvy" (Walter) Elsom and his dog outside 54 Castle Street in the 1920s. He sold fish, fruit and vegetables from a horse-drawn cart in and around about Saffron Walden. He could read but not write, but had a remarkable capacity for mental arithmatic. Today his grandsons, Robert and Roy, and great-grandson Gregory, carry on the family business driving vans instead of horsedrawn carts.

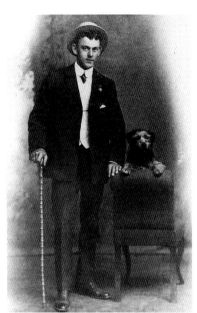

Right: Local builder Frank King in the 1920s. Another Castle Street character, he was a great dancing man who introduced the Tango and the Charleston to Saffron Walden.

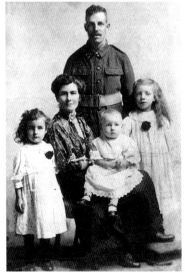

Left: Charles and Ellen Cornell with Marjorie, baby Charlie and Gladys in 1917. They were a wellknown Castle Street family.

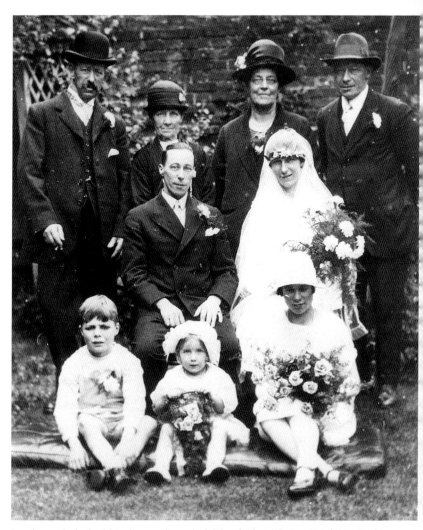

Standing at the back of this photograph, on the left hand side, is Mr Steve Reed. Mrs Reed is also standing at the back, on the right. The bride is their daughter, married in the early 1920s. Steve Reed, was a rag and bone merchant and a staunch Conservative who never missed a night at the Conservative Club, except twice. Once when his wife was suddenly taken ill, and the second time was the night he died.

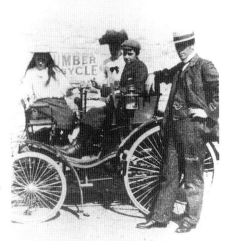

Joseph Wright, with his wife, Martha, their two children, Frank aged six and Louise ten, and his first car, 1890. Joseph Wright was the first car dealer in Saffron Walden (see page 29).

Frank Wright (Joseph's son) outside Audley End House, c. 1900.

Mary Downham Green in her old age. She was a matriarch who bribed her only son, James, to come back to live in Saffron Walden after he had left, with the promise she would buy him a house. She did this, paying £300 (a substantial price in the 1920s) cash, all in golden guineas. Her grandson, councillor and former mayor, Russell Green, still lives in the house in Audley Road.

Town Bandmaster Ernest Pitstow, 1920s.

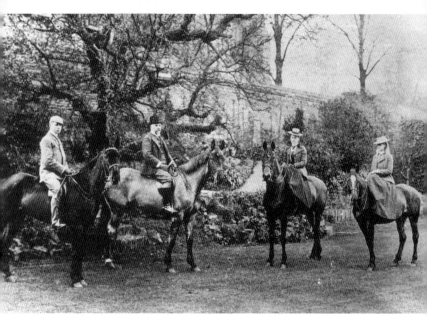

Mr. Turner Collin, noted Saffron Walden solicitor, with his family, taken on the tennis court of No.16 Church Street, *c.* 1898 Turner Collin's son is believed to have been killed in the Boer War.

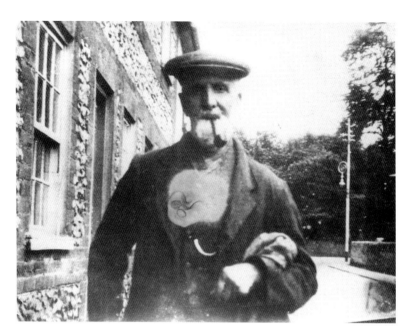

George Westwood, walking down East Street in
the 1920s. He always walked in the middle of
the road, and ate a boiled meat pudding every
day of his life.

Local blacksmith Bill Harper in the late 1920s.

Left: The late Dr Kenneth Lumsden, who ran his Practice at 33 Church Street during the 1930s as well as being Surgeon at London Road Hospital (see page 19).

Opposite above: District Nurses Katherine Lambert, right, and her sister Margaret Anderson, 1971. These ladies were a familiar sight during the 1940s and 50s peddling about the town on their bicycles. Most of the babies born in the town at that time were brought into the world by these two sisters.

Right: Dr Lumsden's wife, Margaret.

Opposite below: The late Maurice Hobbs and his wife Frieda, in 1984. Mr Hobbs founded Saffron Walden Motors in 1938, an enterprise which is still run today by his son and daughter-in-law Charles and Margaret Hobbs.

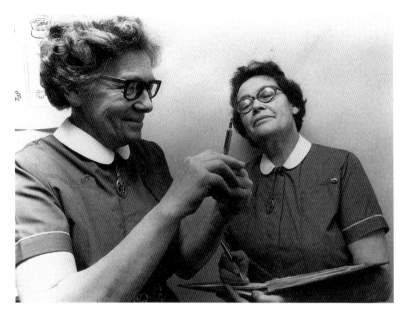

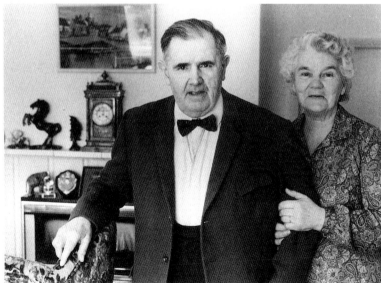

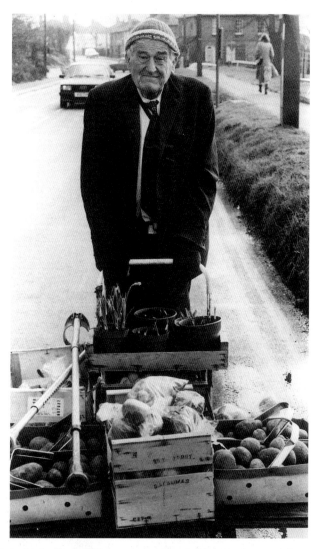

Joe Stojic in Ashdon Road, 1985. Joe, who was 81 at the time this photo was taken, was born in Yugoslavia and fought with the partisans during the Second World War. He was taken prisoner by the Germans and made to swallow poison, but miraculously survived. For many years he was a familiar sight pushing his barrow of homegrown vegetables around the streets of Saffron Walden. He died in the late 1980s.

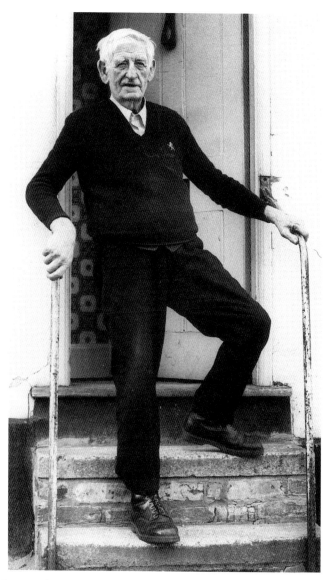

Walter Jarvis standing on the steps of his cottage in Gold Street in 1981. Walter was a wellknown local thatcher, with a wide repertoire of saucy songs. He died in 1984 at the age of 86.

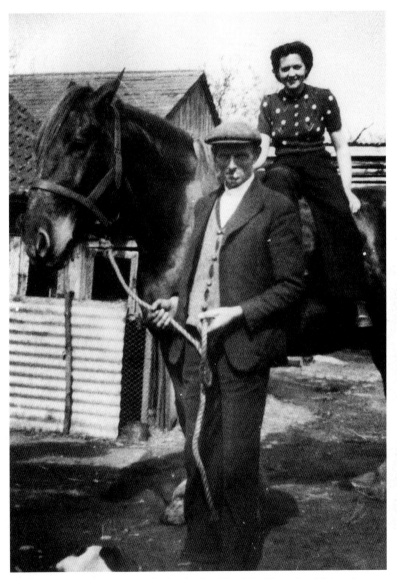

The late Arthur Tredgett, haulier, with his daughter Vera (Mrs. Hanson) and Prince the horse, 1943.

Seven

Walden at Work

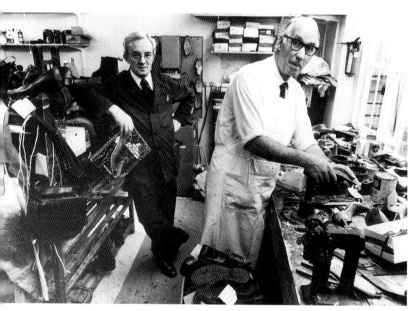

Inside the Repair Shop of DeBarr's shoe shop, 1980.

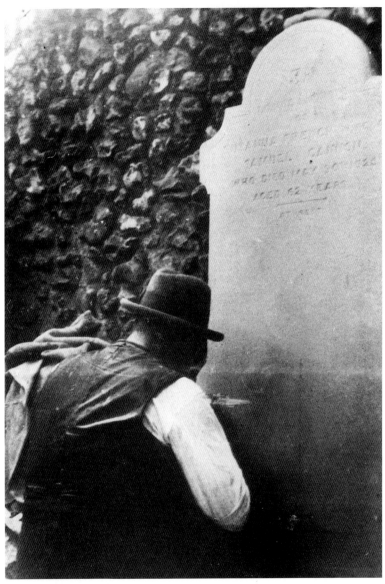

An old stonemason working in the stone mason's yard opposite the Common, 1925.

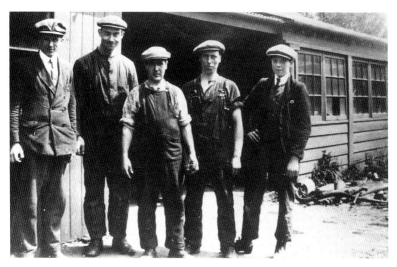

Gasmen at Thaxted Road Gasworks 1935. Left to right, Arthur Downham, Frank Norman, Peter Rayne, Mr. Wraight and Arthur Rushforth.

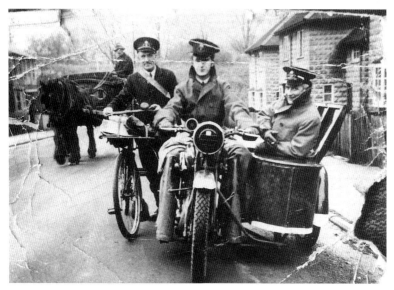

Postmen in Victoria Avenue, 1930s.

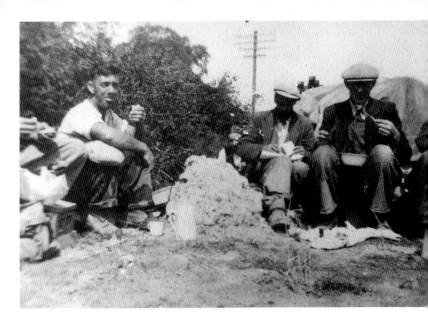

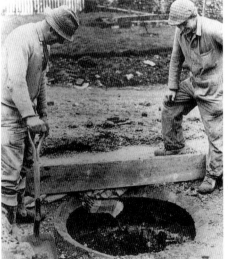

Above: Builder Albert Cox enjoying his lunch in 1936.

Left: An ancient well discovered at 54 Castle Street in the late 1950s by builders Michael and Bill Start.

Opposite above: "Leggy", Bill and Mick Start working on a house in Thaxted in 1960.

Opposite below: Inside Coles' bakers shop at Nos.52 and 54 High Street, 1984. Albert John Cole opened here in the 1930s and the business ran until his sons Christopher and Timothy closed it in the late 1980s.

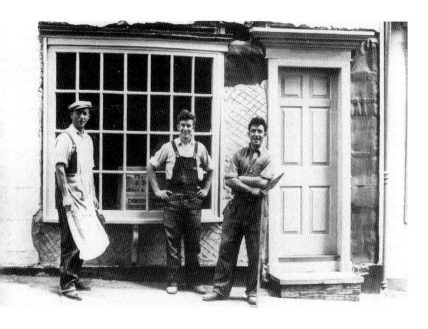

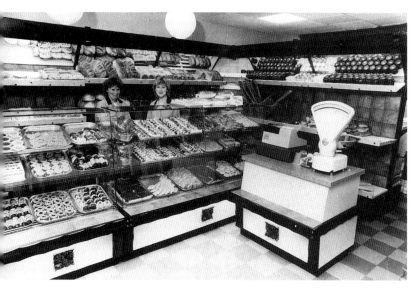

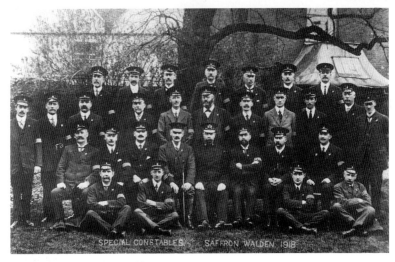

Saffron Walden Special Constables, 1918.

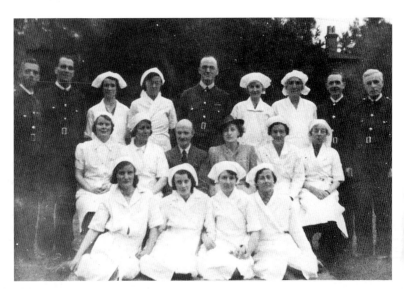

London Road Hospital Casualty Clearing Station. with ARP Warden, Bert Cornell, second right, during the second World War.